Following Teisa

Judi Sutherland

with illustrations by

Holly Magdalene Scott

A CIP catalogue for this book is available from the British Library.

Cover image and illustrations © copyright Holly Magdalene Scott
https://hollymagdalenescottprintmaker.bigcartel.com

Cover and interior design © copyright Neil Ferber, The Book Mill Press UK

ISBN 978-1-9164750-8-3

The Book Mill Press UK
www.thebookmill.co.uk

Acknowledgements

The opening section of this poem was first published as *Teeshead to Cow Green* in *Reliquiae* Vol 8 No 1, (Corbel Stone Press 2020). *The Tees Roll* section was commended in the Troubadour International Poetry Prize 2020. These sections were both included in *Not Past But Through – Poems About Rivers* from Grey Hen Press 2021, edited by Joy Howard.

My sincere thanks go to those who have been so encouraging about this poem as a work in progress: Kate Noakes, Jo Bell, Kathleen Jones and the Poetry Society North Lakes Stanza group, and members of the Vane Women writers' collective. Thanks to Neil Ferber for trawling the Middleton-in-Teesdale parish records for evidence of Anne Wilson. Also, many thanks to my husband, Frank Roche, who visited many of the places on the Teesdale Way with me.

Walk the Teesdale Way:

https://www.ldwa.org.uk/ldp/members/show_path.php?path_name=Teesdale+Way

To all my friends in Teesdale and on Teesside,

with gratitude.

T E I S A:

A

D E S C R I P T I V E P O E M

OF THE

R I V E R T E E S E,

Its T O W N S and A N T I Q U I T I E S.

By A N N E W I L S O N.

NEWCASTLE UPON TYNE;
Printed for the A U T H O R,
MDCCLXXVIII.

Following Teisa — an Introduction.

Nobody seems to know much about Anne Wilson, who, in 1778, self-published a 1600-line poem tracing the Tees from source to mouth.[1] The title, *Teisa,* is allegedly the Celtic name for the River Tees, or of its *genius loci*, a water goddess and may mean 'hot' or 'boiling' in reference to the bubbling character of its water. The poem was written, unsurprisingly for its time, in heroic couplets, with many classical allusions, appeals to the muses, and a long, rambling Arthurian story that intrudes at Rokeby Park. The American academic, Bridget Keegan, deduces that Wilson was working-class and was widowed at a young age.[2] Wilson certainly knew something about cheesemaking, herb-gathering and land drainage, and showed a concern for the welfare of working people. From the friends she mentions in her poem, I believe Wilson had most affinity

[1] https://archive.org/details/teisaapoem00wilsgoog

[2] Bridget Keegan (2002) *Writing Against the Current*: *Anne Wilson's* Teisa *and the Tradition of British River Poetry*, Women's Studies, 31:2, 267-285, DOI: 10.1080/00497870212954

with the area between Middleton-in-Teesdale and Barnard Castle.

Some delving into the online parish records of Middleton-in-Teesdale suggests that this might be our author:

- 26th June 1727: Anne Allason, born to Richard and Elizabeth Allason.
- 23rd December 1747: Marries William Wilson (born 1722), also from Middleton,
- 28th October 1760: William Wilson died
- 24th September 1788: Wilson, Anne, widow, died.

Since that time, a lot of water has passed under a lot of bridges. Sir Walter Scott wrote *Rokeby Abbey*; John Cotman and J.W.M. Turner sat on Towler Hill and Greta Bridge to paint the landscape; Lewis Carroll grew up dreaming of the Jabberwocky in Croft-on-Tees. The Industrial Revolution happened; steelmaking and shipbuilding came to Teesside and left. Even so, many of the places Wilson invoked are almost unchanged after two hundred and forty years.

I moved to Teesdale in 2014 and felt dreadfully homesick for my previous village near the Thames. I started walking by the Tees as a way of getting to know and love my new

environment and decided to repeat Anne Wilson's poetic journey for a different generation.

There's a long tradition of writing about rivers, as an allegory of a human life, as the life of a civilisation, or sometimes as a purely observational study. In embarking on this river-journey I had in mind Michael Draycott's *Poly-Olbion* (the Tees is mentioned in Song 29) and William Wordsworth's sonnet sequence *The River Duddon*. Wordsworth was criticised for choosing such an 'insignificant river' even though he explained in the first sonnet that the Duddon was 'long-loved' and therefore important to his personal psychogeography. He received some endorsement from Robert Burns, who declares in his verse letter '*To William Simson, Ochiltree'*, that, 'Illisus, Tiber, Thames, an' Seine' having all been celebrated in 'monie a tunefu' line', he and his fellow poet should now rather seek the Muse 'Adown some trottin' burn's meander' in their own locality, to 'gar our streams and burnies shine Up wi' the best'[3].

[3] https://wordsworth.org.uk/blog/2014/10/15/wordsworth-and-the-river-duddon/

Above all I was conscious of Alice Oswald's *Dart*; the book that, more than any other, stirred my passion for poetry. I love the way Oswald is equally lyrical about a milk-processing plant as she is about kayakers and wading birds. It also gives me some courage that Oswald is not a native of the area she captured in her poem.

One difference in approach is that Oswald speaks in the many voices of the people who live and work by the Dart. I'm very much speaking in my own voice as an 'offcomer' to the area, learning its history and geography for the first time.

My strategy for this work was to walk most of the Teesdale Way from the Pennines to the North Sea, as well as to research as much as I could about the towns and villages on both banks of the river. I remain convinced that the contrast between the upper and lower reaches of the Tees is much greater than anything a southern river can offer.

JLS November 2021

Following Teisa

How it wells up from nowhere to chase
gravity downhill, becomes a rill,
a rickle of old stones, then hurtles rocks,
purls and pools in reeds, broadens, welcomes in
the tribute of the lesser streams, sways,
nudging its banks, goes garlanded with bridges,
then, brackish in the estuary's slow tide,
pours itself to sea, oblivious.

Where does the river begin?

With the first drop falling from a blade of grass
among the tussocks, haggs and groughs,
a peaty trickle soaking through the moor.
Headwaters where snow makes landfall
on Cross Fell's eastern slope,
high on the spine of England.

My grandmother would say:
'count the weather over from America;
five days from New York'. Rolling a New World
of cloud, picked upon its Atlantic passage,
this is where it disembarks.

This river has a northern voice, sampling the geology
with a liquid tongue, the southernmost of three,
hauling Pennine waters to the great North Sea.
Channelling the downpour that rinses out the heather,
carrying the stain of iron and bitumen
and the deaths of flowers, down from the watershed,
tasting the rain and the meltwaters, Tees flows faster
than any other, roiling, bubbling, waterfalling;
two days ride down to South Gare breakwater.

Kittling over dolerite, the new river goes paddling,

babbling of moss and all the secrets buried

in the peat. Gathering Trout Beck from Great Dun Fell –

where water pounding down the leat

washes out lead-laden ore in hushing-gulleys –

it finds a lake submerged within a lake,

the old Weel, swollen and penned back

for the factories, ninety miles downstream,

that used to thirst and beg for water.

Red grouse low-fly in pairs, skimming over heather;

a curlew calls, the sheep bleat back an answer.

Under the wavelets, a Bronze Age village drowses

drowned, sleeptalking of the ancient days

when Cow Green pastured cows

and was green.

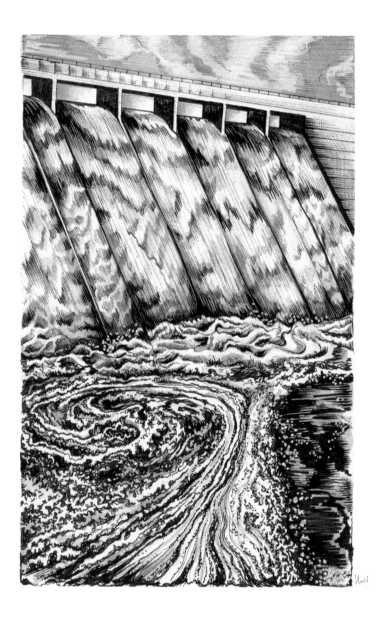

4

Cauldron Snout

Below the concrete dam, a dry spillway,
while the river is re-birthed – an indignity
of outfall – with barely time to find its feet before
tumbling at forty-five degrees, a whitewater staircase
with a grand balustrade of columned rock.

The Teesdale Assemblage

How do we manage to be at the centre of this country
and still in the middle of nowhere? It's no bad thing;
islanded by mountains, bypassed by motorways,
preserved through centuries; an Ice Age reliquary
of Europe's sub-Arctic flora – the 'Teesdale Rarities' –
seeding their survival in our upland meadows;
the Teesdale Violet, rare and purple-blue
on sugar limestone, gentian and bog sandwort,
 the double-dumpling globeflower,
eyebright and self-heal,
marsh marigold and yellow-rattle, seed all set
before that single cut. An ancient rhythm
as the swept arc of the scything blade
makes fragrant hay while the sun shines.

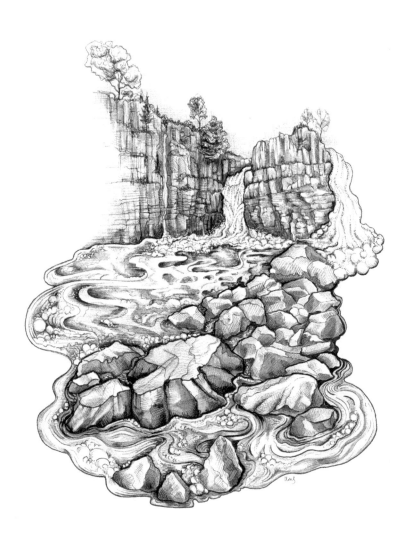

6

Margaret Bradshaw, seventy years a botanist,
looks for 'Lady's Mantle' – *Alchemilla* –
not the acid-green fizz of naked blooms
that lavish every Teesdale garden
but deeper in the Dale, the rarer species:
the Large-Toothed, the Velvet and the Starry.

High Force

The Whin Sill's edge is a sudden cliff
the careless river plummets over.
In flood, the fall, or force, or foss,
plunges down each shoulder of the central rock
that stands like a warrior, a shield-boss
held astride the tumbling river.
Above the force, take the grassy path,
rabbit-trimmed, bordered by gorse,
wild raspberries and juniper.

The Tees Roll

This was a flashy river. After a storm
the shallow stubborn bedrock
beneath the gathering grounds
forced the river to take rainfall
all at once; then, unannounced
and unpredictable, the great Tees Roll
went barrelling down. A yellow wall;
another river, riding bareback
on the first; like the shovel of a great digger
ploughing branches and boughs,
and the bodies of feckless yows
before it. Sometimes it took out bridges,
sometimes men. Corpses rode the wave,
carried downstream as far as Blackwell.

The landlord of the High Force Hotel
would telephone to Middleton;
'Stop the cars and close your bridge
we've got a roll coming down'.
Some remember the warning sound
of the dangerous river, singing.

Once, a whole wartime platoon
of lowland men was washed away,
with their bridge pontoons, at Barney.

Tamed by reservoirs, the old Roll
is history, but wary anglers, wading out,
still push a twig into the bank
to mark the level. Even now,
in angry spate, a flood will rise from nothing,
calling out warnings from monitoring stations
of hundreds of Cumecs passing.

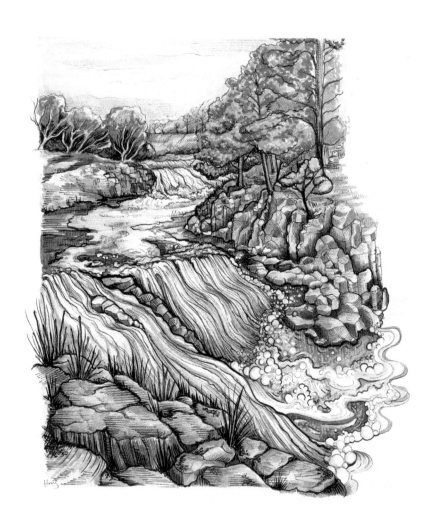

The small thunder of the force,
the alternating bowls and basins
over which the torrent pours,
are the water-feature of a Japanese god.
Stonework squared off in flat planes,
a flagstone garden underfoot,
purple-flowering thyme caught
in the pavement's fractures.
Hokusai pine trees grow without soil
clinging to the cliff like timid bathers.

Over the falls, kayakers come toppling
in bright boats, lanceolate
like so many fallen willow leaves,
red, green, yellow, amber, riding
the race, then treading water
with their paddles, holding steady
in the darkwater pool.

Wynch Bridge

Scuds of white foam mass and slide
in flowing plates, down to the silverblue
of footbridge mesh and hawsers –
the third bridge of its name to span the ravine.
Anne would remember the second, long gone,
where nine haymakers crossing together
caused a broken chain, a tipping point
and one of their number gone forever.
The tilt and sway still feels like danger
now we're asked to tread the planks alone.

The river cuts a deep gorge, the path runs through bracken;
on one side, the dun cliffs of Holwick Scar reckon
with the hillside. There are orchids here, a festival
of tiny bells. Which miniature bee can reach their nectar?
Along the footpath, foxglove, cranesbill, great burnet,
knapweed, wormwood, yellow hawksbit,
Lady's Bedstraw, common mugwort
bird's eye primrose and melancholy thistle.

Scorberry Bridge

Three strands of quiet water braid
beneath Scorberry Bridge, with its good
stone footings. The character
of the river here is flat and slabby,
but a quickening central channel
pushes up wavelets, purposeful,
a fell runner among Sunday hikers.

Middleton in Teesdale

Middleton, a place, Anne Wilson tells,
of 'people neither splendid, rich nor poor'
where Hudeshope Beck pours from the fell
to meet the river here, beside the livestock mart
where Swaledale yows and gimmer lambs,
mules and rams are penned for sale; thick-coated,
curly horned, speckle-legged and bold.

Under the arch on Masterman Place
is a Newtown of 'neat and convenient cottages...
the chaste and appropriate design of Mr. Bonomi';
a village heavy with lead and temperance

13

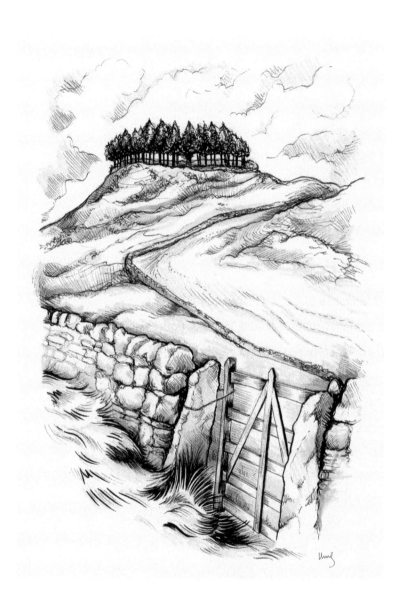

for the most deserving workmen
of the London Lead Company,
whose Quaker sensibilities
abhorred the scourge of alcohol. Instead
let the miners take their toxic chances
hewing blue-grey bouse from the adit
with pick and hammer, plug and feather
crowbar and candle.

Kirkcarrion

Above the town, a stand of pines on a barrow,
Bronze Age elders whose watchful eyes
follow. Turn around, you'll swear they've shifted
in their rootball, their wooden footfall
silent on the hill. In comes the Lune
from its lonely dale, escaping the broad dams
of Selset and Grassholme.

This bridge has linked the riverbanks
since the fifteenth century. Sheep and geese,
farm carts and haywains staggered across
between the hillside farms of Eggleston
and Romaldkirk's low fields, its single track
now policed by traffic lights, while the house
on the western bank turns its back
on the river and stares uphill.

The River Balder flows in beneath the bridge
at Spout Bank, having filled the man-made lakes
of Balderhead, Blackton and Hury.
Now the Teisa reaches Cuthbert's town
where the saint's pallbearers laid down
their bier of holy bones, before trudging on
to Durham, where, finally they dug in their heels
vowing they would carry it no more.

There's been dairying here since long before
Anne's poem. She and I are not 'silent
on the subject of cheese'; of milk
gone bad, come good again,
shapeshifted into solid character
by sly bacteria, the maker's hands
and the wild herbs of the pasture.
Working in the quiet of the creamery;
the subtle alchemy of heat and pressure,
the white and blue moods of ripening mould,
and the long, cool patience of the cellar.

Towler Hill

Below Lartington, but above the town
the lightest pencil sketch marks out
the Castle; a ripple of curtain walls,
the riverbank and the Startforth side
in Turner's notebook. Cotman's castle lies
in middle distance, between blue-grey woods
and a faraway ridge of Yorkshire Dales.
I can tell both men that nothing much has changed.

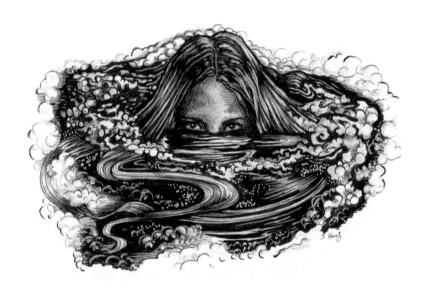

Flatts Wood

Peg Powler's pond. The Hag of the Tees
A Jenny-Greenteeth, a Grindylow;
with her crown of suds and her hair of weeds.
Don't step too near the riverflow.
She's crouching there in her garden of reeds
her hands are the tug of the undertow,
she'll haul you by the ankles, deep,
pound you with rocky knucklebones
'til your body is hacked into cuts of meat.
Don't give her a chance to drag you below
if you want to go home in one piece.

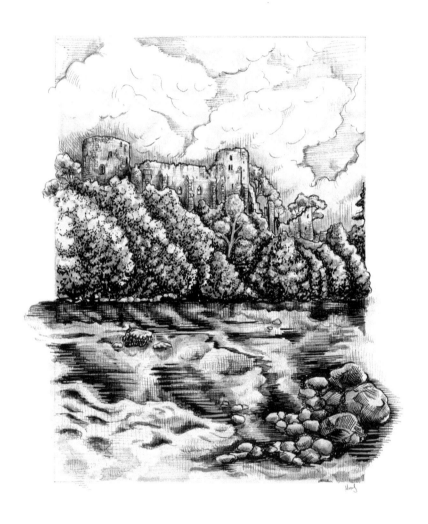

Shallowed by reservoirs
the wadeable Tees reflects the sky.
Breezes sparkle the water. Yellow oak leaves
play pooh-sticks with the bridge. The gymnast river
vaults handsprings over the weir's beam.

Anne, here were your Halcyon days; the bird
with 'feathers red and green' flits through your poem.
Now we might call it electric blue,
but it's still the kingfisher darting through
these hanging trees. How many brilliant generations
separate my kingfisher from yours?

The town collects in the bowl of the hills;
a clutch of eggs in a nest, surprised
to be here, all stone and slope
where nature wanted heather.
A beat outside its boundaries, the road
climbs to the moor, where thin trees stagger
at the punch of weather.

From here the hills are blue and unremembered.
On many days, long sleeves of fog
hug them grey. We can see the rain an hour away,
siling over Citron Seat and Stang Top.

Listen for the trudge of soldiers' boots
marching from Binchester to Bowes
a cold wade in the river's race.
A chapel now stands in the Legions' way,
but you can still sight the run of the Roman road
from Galgate Greens to Deerbolt Bank.

The castle faces outwards, moated by the river.
Its concern is not the locals. It never
glances their way. Watchful from its walls
it is preoccupied with north.

A town of high-windowed weaving-lofts
and mills – Ullathorne's and Longstaff's.
Clog and patten-makers, carpet stitchers,
chamois-glovers, woollen worsted weavers,
twiners of thread for saddlers and shoemakers,
flax-retters, breakers, scutchers, hecklers,
cordwainers, dyers, fullers, ropemakers.

Bowes Museum

A Loire chateau, bigger than the town's ambitions,
a brooch pinning one corner of the fields,
jewelling the town with paintings,
and a swan who dips his mechanical head
into glassy water. Joséphine, your treasure
gave the town a tiny Paris, did it make up for the lack
of salons, boulevards, and theatres?
Outside, the inland gulls are skeins of pearls
rising up from the banks of the river.

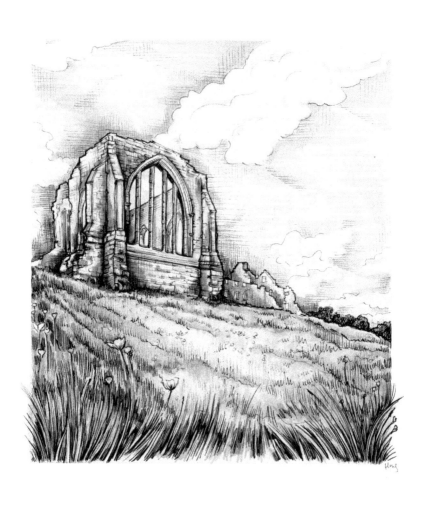

Egglestone Abbey

Below the lonely abbey of St Mary and St John,

a pool, just deep enough for swimming in.

According to the manuscripts,

the vow of poverty wasn't hard to keep

for these White Canons, chanting Lauds

between their first and second sleeps.

You can hear the river from these ruined walls

and an echo of their psalms and liturgy

at the riverbank. I like to think of novices

hanging drab habits on a bramble bush

stretching thin, white torsos, diving

in, remembering to keep their gaze

above the surface, the dappling light

on water shielding emerald-tinted limbs,

saving them from occasions of sin.

Under the graceful arch, and then
the path goes swithering over-stile
and up-step, around a wheatfield's edge
and back again to the river, which,
while we weren't looking, has grown up,
broadened, calmed; but it's not too old
to play hide and seek as it flows on
lower than the road.

Meeting of the Waters

Blocks of Teesdale marble,
the regular strata on the northern bank
look built, the foundations of
a Pennine Mycenae. This is the stuff
of church fonts, the crinoid stone
polished quiet in a dozen parish naves
half-remembering a time when
it cradled much greater waters, sanctified
the water-beetle and the stickleback.

Here's where the Greta brings
its tribute in from the old North Riding,
picking its way past Brignall Banks,
Scargill and Barningham,
trailing in its wake a vassalage
of gills and gutters, becks and sikes:

Ay Gill, Red Gill, Burnt Gill, Sleightholme Beck,
Dry Gill, White Stone Gill, Polly Gutter,
Ease Gill, Rea Gill, Great Wygill,
Frumming Beck and Back Gutter.
Hug Gill, Thwaite Beck, Eller Beck,
Seavy Sike, Stang Gill, Gill Beck,
Woodclose Gill and Tutta. The Greta
ambles in sideways, telling it slant.

A leap and a flop. A long shape
rises briefly from the water,
dark against stone-coloured reflections;
a brown trout, jumping for flies.
A loop and a flap. Broad wings
circle slowly at tree-level,
trailing long feet behind them;
a heron, searching for trout.

Rokeby

Rokeby is a storytelling place,
a rural muse's garden. She's been caught,
and more than once, whispering couplet tales
into a poet's ear. Where waters meet,
colliding like ideas, she conjured
Anne's King Arthur to the stage; then legends
of Civil War and derring-do for Walter Scott,
gothic, heroic, overblown.

Mortham Tower

Lady Rokeby, 'Mortham Dobby'
still trails her white silk train,
carrying her head before her like
an offering. An enterprising priest
confined her spirit under Dairy Bridge
until the great wave of the Tees Roll
toppled its arches. Now she wanders free
around her pele tower, her blood
still spattering an ancient staircase.

Whorlton Bridge

The river is shallow, but its gorge is deep,
the approach to the tollhouse zigzags down
and down. A bridge built for 'chaise, gig, coach,
wagon, wain, cart, or other carriage';
for droves of cattle, pigs, or sheep,
hangs over the ravine. Each car takes a deep breath
and clatters across the xylophone planks
of the Whorlton and Staindrop Turnpike.

A path ducks underneath an arch of roses
to a church the colour of a raised loaf.
In the cool chancel, clouds pass
behind stained glass. Hogback stones
and the fallen fragments of a Viking cross;
'Panels of four-cord interlace. Carrick bands,
roll-and-cable moulding'. In this place you can hear,
fifty yards away, the river gurgling. And somewhere
near my ear, a lone bee buzzing.

The churchyard tips down to the water's edge
long-grass headstones wear skulls
and crossbones. Across the lane, an orchard wades
in cow-parsley almost to its knees.
Just a glimpse, here, of the flaggy Tees
beyond a notice; PRIVATE FISHING.
No use wishing it were otherwise,
the current is strong; NO SWIMMING.

Winston Bridge

At Winston Bridge, a Spitfire flew slow
slicing on a wing-edge through the valley,
straightened along the tea-brown Tees
trimming with a wing-wag, dipping low
beneath the bridge; its Merlin engine
rumbling under the long stone span,
pulling up, into a roll of celebration.

Gainford

Here's where the railway came and went
from Darlington to Cumbria; crossed the Tees
and back, uncertain of the way. You can trace its route
in satellite view, bordered by its cuttings;
all that's left of the rail track now
is a double row of hawthorn in bloom.

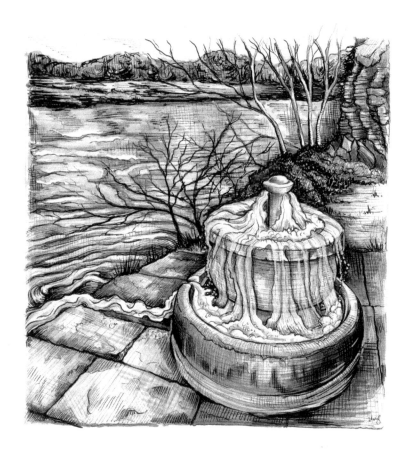

Gainford, you were just too late
to be Buxton, Bath or Harrogate
but your spring still bubbles from a marble font –
a cauldron, a brimstone baptism – and gutters down
to join the river. A whiff of sulphur and ramsons
a gnarl of roots in the sandstone cliff,
a mallard flotilla in eclipse. Green reflections
hanging from the further bank. And Spa Road
still wandering hopeful through the village
above St Mary's Church, The Green, and Piggy Lane.

Piercebridge

Morbium, where Dere Street crossed. A succession
of Roman bridges, taking soldiers to garrison.
Where the river ran, before it wandered north,
bridge piers still squat; a tumble of dressed stone
and paved washway, excavated only by the mole,
between the sounds of cars and water –
a double roar of road and river. An offertory place,
coins and tokens thrown on to a shifting island shrine.
Silver denarii, a gold and agate ring, figurines
of Cupids, horses, and a leaden goat, hallowing
this crossing. Now a fallen tree bows down
in the shallows. The village huddles inside the fort
as it has for two millennia. Farm buildings here
are low and limewashed, with red-tiled roofs;
having learned to be farms in Roman times.

Broken Scar

The pumping station is a chapel to sanitation;
red brick, arched windows, a steepling chimney.
Penned in rectangular tanks, the captive water
is churched through sandy filter beds,
submits to the will of the gas engine;
(R. Hornsby & Son, Grantham & Stockport).
The flip of magneto, roll of eccentric cams,
the exhaust stroke's contemptuous hiss,
a smell of hot metal and vapourised oil.
The great beam engine, liveried with paint,
nods quietly, a beast of burden dragging
water against its will, bound for Harrowgate Hill
to pour down pipes supplying Darlington
with public health on tap.

Darlington

Choosing the lesser river, not the great,
Darlington sits quietly, as Quakers do,
while seventeen modest bridges cross
the Skerne: a wash of coal dust down
from Trimdon. A town of three towers,
the church, the station, and the market-hall

saying; Faith, engineering and farming are our stock
in trade. We built our town on this trinity of pillars,
and on this backwater we shun the showy Tees.

Croft on Tees

This has always been a boundary river
holding the line between Bernicia and Deira,
Roundhead and Royalist, even marking England
from Scotland, for a time. The ceremonial frontier
of York's North Riding with the County Palatine.
It's been the constant factor
while administrations wander,
and counties bleed across its border,
like watercolour across a pencil line.
At Croft, Durham loops leisurely
south into White Rose territory
and on this bridge, a delegation waits
to welcome each new Prince Bishop
taking possession of his estates,
presenting His Grace with the Conyers Falchion;
the great sword that slew the Sockburn Worm
who lurked within the river's next smooth turn,

(we'll get to him in good time)

for the Tees itself runs serpentine,

snaking its way along the valley.

Through a grey gate is St Peter's church

where the rector's son would dream through Eucharist

of rabbit-holes and looking-glass

Red Queens, Mad Hatters, Cheshire Cats,

sleepy dormice, soup tureens.

Hurworth on Tees

By the 'Otter & Fish' (bars & restaurant),

there's a Private Bridge (no bill posting).

In August, the river is low. Canada Geese

plant their brown feet, wading the water.

Rafts of torn branches pile, pinned against bridge pillars.

A striped mattress and a twelve-paned door,

fly-tipped, rest in the shallows.

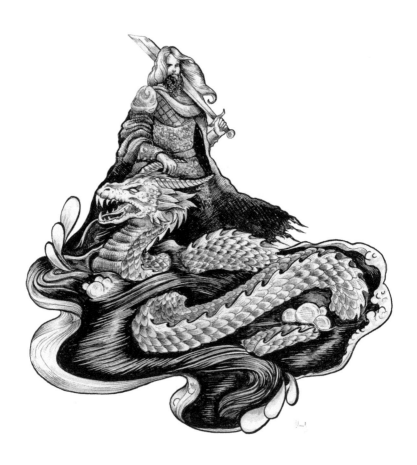

Sundown; flocks of starlings
swirl over Low Hall Farm, a murmuration
of tall Tees' tales; shaping a fish, then an otter,
a cloud, a leaf, a waterfall, and isn't that
a seal? No, a whale? No, a cargo freighter?
Starlings have seen it all.

Sockburn

This country is full of dragons, wyverns, worms –
here's the legend of a serpent that fell from the moon,
but cometh the monster, cometh the man
to spill the 'purple life' from the reptile's heart.
What folk-memory or remembered fear
is honoured in this proto-Jabberwock?
Imagine, gliding round this riverbend
where the Tees writhes round through a lazy loop,
a Viking prow, a dragon figurehead,
a warship threatening these peaceful coils of water.
Now nothing but a story travelling
the ages, and the stone end-beast
of a hogback grave.

A ramble of houses along the green

as cute as barley sugar. And on the other side

a steep-mown bank; tall with knapweed,

goldenrod and teasel; the river

sliding reflective through a branching screen.

High above the hollow, a swirl of birds

snapping at gnats; swift and swallow.

A plump plane rises from the runway

hauls itself into the air above the trees.

Here at high tide's furthest reach
where once salt water ran to meet the sweet,
a small town grew. A fishing spot, a marketplace
broad and busy. Bridges are Yarm's fortune.
Bishop Skirlaw's bridge still takes the road
across the Tees. The round arches
of the viaduct, (Engineers; Thomas Grainger
and John Bourne) with chimneyed houses
hunkering beneath, still take the trains.
Anne Wilson's poem speaks of 'barks'
upriver at Low Worsall, each one raised
on four high tides to sail this far inland –
but Yarm's neighbours stopped its brackish trade.
The bridge that Stockton built
blocked tall-masted craft, and Yarm's pretensions
as a port. Yarm's all the prettier for that.
A careful sign makes sure the traveller knows
they are entering into Yorkshire.

'Robert Malet has these lands and they are waste.'
And in the third year of the Conqueror's reign
the people of the North rose up to fight, to claim
their right to their holdings and their steadings.
This angered the King and, stern beyond measure,
he marched his armies out, between Humber and Tweed
to harry and subdue the rebel towns and farms
to fire the thatch, destroy the crops and cattle.
Many folk fled southwards for their lives.
Three quarters of the people and plough-teams slaughtered.
This stain upon the Norman's soul all told in Domesday:
'wastaes est', village after village. 'Hoc est vast'.

Tall office blocks of brick and dull green glass
crowd around Council of Europe Boulevard.
A sine wave of a bridge stretches bank to bank
and calls itself Infinity. On the skin of blue water
glides a rowing eight, oars in perfect synchrony –
a carbon fibre water-boatman.

'Merchants like princes', Anne Wilson wrote
and that was before the fine heyday of the town;
Corporation Quay and Castle Moat,
North Shore, Hubbocks, South Shore, Blair's.
Shipwrights, marine engines, sheerleg cranes
and blast furnaces, all along the riverbank
from here to Skinningrove. Stockton High Street
as broad as the lowland Tees. But the river's meander
tested the patience of Stockton's ship-owners
and was cut to flow straight. Nothing must hinder
the ships and their cargoes; the wool and the butter,
the lead and the pig-iron, the coal and the rope.

Tees Barrage

A barrage turns the Tees into a freshwater lake
from Worsall to Portrack. Below fish-belly gates
the river foams like a pulled pint. Black-headed gulls
perch on every globe-shaped streetlight.
Huge and floating on their speckled backs,
beside the fish ladder and the navigation lock,
Atlantic Grey Seals lie in wait
for every silvered salmon. Fishermen hate
the efficiency of those whiskered snouts –
the Tees could be a decent salmon river
if there weren't so many seals about.

Newport Bridge

Ahead, the red and silver of the Newport Bridge
built to powerlift a length of road
into the air. Now, after more than eighty years
tall ships no longer need to pass,
docking on the downstream side of town.
So the oak-panelled winding-house was left unmanned,
the bridge let go, and set the roadway down.

All along the Tees, there are otter sightings

but here, between the Leven and Lustrum Beck

was where they first returned, after thirty years away

while water spoiled by industry went 'stinking

like a thousand Tom cats'. Now visitors watch them play

on the riverbank, looking for the v-shaped wake

of sleek swimming heads. The otters are here

because the fish are back.

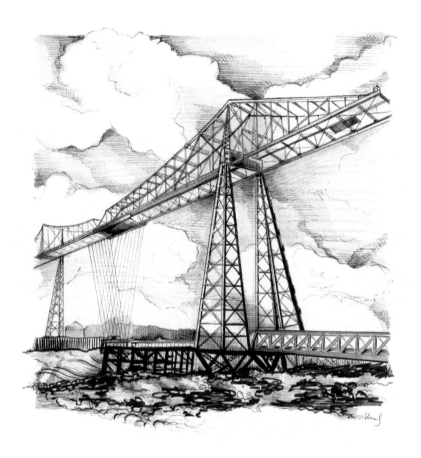

Transporter Bridge

Who would design a bridge where traffic hangs
suspended from the belly of the thing?
The steely haunches of this quadruped
stand on foursquare feet above the riverbed
extinct almost from birth. Two hundred men
or nine cars, plying back and forth by gondola
from Port Clarence to the 'Boro,
on a ferry-of-the-air. I half expect
to see the writhe of a snaking neck
and grabclaw head, rising to stretch
above its arched blue shoulders. But the dinosaur
is dead, its ponderous purpose overtaken
by the fixed humdrum of the flyover.

Middlesbrough

Mydilsburgh; a halfway house
midway between Durham and Whitby.
A steppingstone, a place of prayer
a place that conjured salt from seawater.

Its ancient farmsteads haunt the streets
that trampled down their fields:
Brambles Farm and Berwick Hills
Hemlington Hall, Thorntree and Saltersgill.

Seek your fortune, Joseph Pease,
build your coal staithes on the Tees,
dig out your ironstone, John Vaughan,
Henry Balckow, set up your foundry.
Where there once were woods and farms,
where there once were prayers and psalms,
raise Ironopolis, the Infant Hercules,
hotter than hell, born dark and bloody.

If you were born here, this was your beauty;
jobs and pay-packets, food on the table,
a fire in the hearth. Not easy, but steady.
You could call it a living, constant and stable.

There's a lot of river-water passed
beneath Teisa's spans and arches
since those days. And a lot of bridges built

by Cleveland Bridge and Dorman Long
designed for other crossings, from the coaly Tyne
to Sydney Harbour and the wide Zambezi.
One hundred and fifty years for a town
that never was a city, to rise and fall.

Give us some work to believe into being,
to make with our brains and our hearts and our fingers;
work for the children of welders and turners,
steelmen, shipyard men, chemical workers,
the skilled, the apprenticed, the Easter Leavers.
What's left for us now that they've halted the furnace?

This thug river has 'love' and 'hate'
tattooed on its knuckles. It's been
the making and the breaking of this town.
Old St Hilda's parish long since pulled down
or boarded up – not much left of Middlehaven
but the Old Town Hall, presiding over nothing
but a clock tower and a few sparse pubs
still standing in a flattened neighbourhood.

Anne Wilson longed for sailing ships
from the Mississippi and Hudson Bay
but the North Sea ports all face away
from the Atlantic trade and lean towards
the European eastern side.
The 'Boro's bills of lading deal
in Durham coal and Cleveland steel.

Round the headland, a Brent oil rig in dock
stands vanquished on vast, rusted legs
for the long disgrace of decommissioning,
its bones picked clean by cranes,
 a sky-burial at the end of the Oil Age.

The Black Path

Take the saltmarsh path, the old way
the ancient way, treading on steel-slag cinders,
a route trudged by shift workers, dockers and sailors,
that gave a little ground to the railway;
pushed to one side but it couldn't be built on.
Between slab fences, and galvanised palings
alongside pipelines and chain-link and railings

brambled and nettled, fly-tipped and littered
it runs between factories, derricks and silos
and finally, wearily, back to the river.

Teesmouth

An urban beach, where industry
swaggers arrogant down to the water's edge
where vents, conveyors, cranes and chimneys,
breach the horizon of the Cleveland Hills.
We pass a makeshift stage, a speaker stack,
tail end of last night's beachside rave
a scent of weed, and the biscuit-sweet
exhaust of Frutarom's spray-dried flavours.
Tugboats struggle, cream and black,
past warehouses, docks, and a patchwork fleet
of rust and yellow sea containers.
Teesport carries the tradition on –
twenty six vessel-calls per week, ideal
for 'agribulk and project cargoes,
metals, ores, and forest products'.

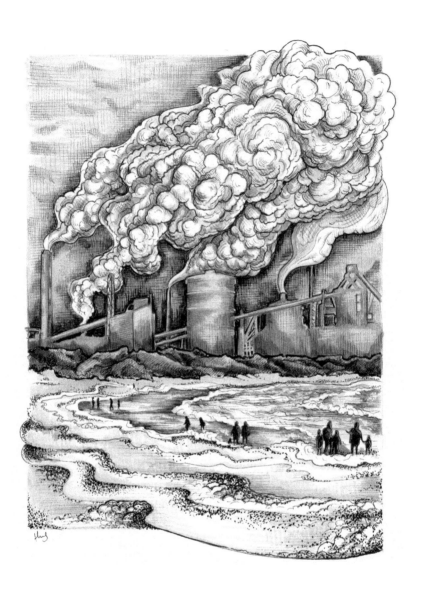

Now they've 'tapped the salamander'
and the steelworks' giant hammer
is silent, still. The furnace cools,
the red glow dulls. No more long turns
of the rolling mill, by this steel river;
two thousand working men, and more,
drop their heads down, and stare
at hands that bear old scars.

Wind and tides furrow the beach's brow
in a new pattern of dips and ridges
shadowed with sea-coal specks. The marks
of our feet, and the pawprints of dogs
are tide-washed, temporary.
Soon, no-one will know we were here.

This poem is ninety miles long

And this is where it ends. The river

empties itself into infinite sea,

along with the outpourings

of its sister-rivers, the Wear and the Tyne.

This water will embark once more

on a ship of cloud, to be carried in

to the Volga, the Ganges, and the Rhine.

One day these droplets will coalesce,

slip their airy moorings,

touch the Pennines, sail the Tees again.

Judi Sutherland was born in Stoke on Trent to Geordie parents, spent some time as a child in Northern Ireland, and since then has lived all over England from Sussex to Durham, as paid employment has dictated. She trained in Microbiology and Biochemistry at the Universities of Leeds and Nottingham respectively then pursued a career in the pharmaceutical and biotechnology industries, developing new medicines.

Judi obtained her MA in Creative Writing in 2012 at Royal Holloway, University of London, where she was awarded the Margaret Hewson Prize. Her poetry is mainly concerned with place, identity and belonging, and she has an interest in landscape and history — creating a 4D map of the places we inhabit. *Following Teisa* was written between 2014 and 2020, when she was living in Barnard Castle, County Durham.

Her poems are widely published in magazines such as *Oxford Poetry, Prole, The North, New Statesman,* and online. She blogs at *judisutherland.com.* Her first pamphlet The *Ship Owner's House* was published by Vane Women Press in 2018.

She is currently living in Malahide, North County Dublin, Ireland, with her husband and two rescue cats, where she is

writing poems about her new surroundings – *Fingal* – the Land of the Fair Strangers.

Also by Judi Sutherland:

'"The Ship Owner's House" is built on sands of displacement. Judi Sutherland echoes the cry of the refugee, the exile, a stranger in a strange land. Home is something she leaves behind. Her poems have crossed several cultural borders to the North... Memories move with her into the 'terra incognita' of Teesdale, question what we mean by locus, a place where we belong. Intelligent, imaginative, heartfelt, these are salutary poems for our times.' – Jackie Litherland.

'The quality of the poetry leaps from the page'- Rennie Halstead, *Sphinx.*

'Images of rootedness lost, the struggle to identify with a new place or circumstance, and inevitable departure pile up page after page, lending the whole volume a rich, melancholy air.' – James Roderick Burns – *London Grip.*

'The Ship Owner's House' is available from Vane Women Press.

https://vanewomen.co.uk/press.php

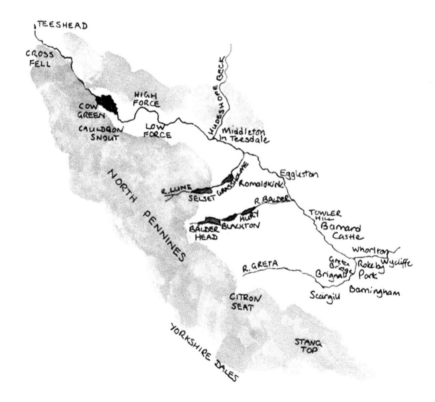

TEISA

or

the

RIVER TEES

from source to mouth

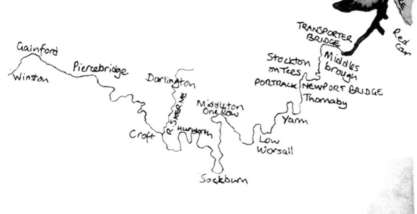

Ingram Content Group UK Ltd.
Milton Keynes UK
UKHW021303160423
420245UK00024B/920